COLOR
GROOVY

COLOR
GROOVY

THANEEYA MCARDLE

NORTH LIGHT BOOKS
CINCINNATI, OHIO
www.artistsnetwork.com

INTRODUCTION

In addition to an overview of basic coloring materials and techniques, this book provides you with dozens of fun, groovy designs to color and style. You can use multiple colors and more than one medium if you wish. You could even draw some different shapes to create your own patterns within the patterns. The possibilities are endless! Each page can be as beautiful and unique as you want it to be. Experiment and have fun, because the best thing about coloring groovy is that there are NO RULES! When you color groovy, you can let your imagination take over and color the world the way *you* see it. So relax, let loose and express yourself!

MARKERS

Markers are a wonderful medium to work with. There are several brands and varieties available for purchase. Different types and qualities of markers will produce different effects and results.

Copic Sketch markers are alcohol-based, non-toxic and fast-drying. They come in hundreds of color choices and are refillable. This makes them great for experimenting with different techniques for groovy results. They can be purchased individually or as a whole set.

For those on a tighter budget, Copic Ciao markers are a good alternative. They are similar to Copic Sketch markers, but less expensive because they are smaller and hold less pigment. They also have fewer color choices available.

Prismacolor also offers a good quality line of markers. They have broad nibs (tips) and come in many different colors, but are not refillable.

Crayola markers are probably the most common brand of water-based marker. They are easy to find and work well for layering colors. They don't blend as well as Copics because they tend to leave "brushstrokes." But if all you're looking for are just some simple, bold and bright colors that won't cost you a fortune, Crayola markers are a fine choice. Just keep in mind that the key to using water-based markers is to work fast and to layer your colors from light to dark. (And be careful not to spill any water on your finished pages!)

IMPORTANT!

The brands mentioned in this book are suggestions only and not absolutely necessary. You do not have to buy the most expensive supplies in order to get great results with your coloring pages.

MARK-MAKING WITH MARKERS

COLORED PENCILS

There are many different brands of colored pencils available spanning various levels of quality. For the most part, the price of colored pencils depends on the quality you choose. Brands like Prismacolor, Caran d' Ache and Faber-Castell produce good quality colored pencils that contain high pigment levels, are break- and water-resistant and are easy to use. Experiment with different brands to find what you like and what works best for you. To get the best results with colored pencils, it's best to work from light to dark, adding more layers as you go.

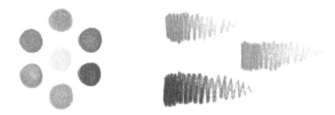

MARK-MAKING WITH COLORED PENCILS

BASIC TECHNIQUES

The following are a few very basic techniques that can be used to enhance your coloring designs. You can use them on their own, or mix and match them to create groovy effects.

LAYERING: Layering creates volume. Each time you layer one color on top of another, that color becomes gradually darker. While the most common practice is to layer families of colors, you can also achieve some interesting effects by layering complementary colors.

BLENDING: Blending allows you to mix different colors together. Apply your first color by shading it from dark to light. Then overlap the lighter area with another color. On the overlapping area, shade back over with the first color until the colors are blended smoothly. Unlike layering, blending creates a smooth gradient. It can also be used to suggest depth and distance. Use this technique when you wish to make an area of your design appear to recede from view.

SHADING: It is easiest to work your way from lightest to darkest when shading, though you don't absolutely have to work in that order. Layer even strokes lightly for the first layer, then shade another layer on top to create a more intense color.

CROSSHATCHING: This technique involves a series of lines overlapping each other. First create a group of parallel lines. Then use the same color to create another layer of parallel lines that overlap the first layer. Make sure the second layer of lines goes in a different direction from the first layer. Repeat the method using as many colors as you desire to create interesting effects and textures. The more layers you create, the more intense your colors will be.

CRAYONS

You can use all the same techniques with crayons that you use with colored pencils, but the results will look quite different. The best thing about coloring with crayons is that you don't need to invest a ton of money to get groovy results. Even the largest set of high-quality crayons will be less expensive than the smallest set of fair-quality colored pencils.

While there are many brands of crayons out there, you'll get the best results if you stick to Crayola—the original brand. Crayola crayons have rich, high-quality pigment and a low wax content. The cheaper brands tend to be heavier on wax and lighter on pigment, so the colors just aren't as rich.

Different crayon pigments have different characteristics. Some are very rich and opaque, meaning that they will cover the paper completely with a rich saturation of color. Others, however, are more transparent and barely show any color when applied to the paper. Try out each crayon a piece of scrap paper before you begin coloring your designs. Often, what shows up on the paper is not quite the same as the way the crayon appears in stick form. Experiment with colors to see how they look when applied lightly, heavily, or layered over one another.

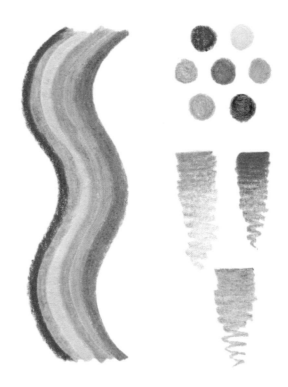

MARK-MAKING WITH CRAYONS

TIPS FOR WORKING WITH CRAYONS

- Keep a sharp point on your crayon at all times to keep your colors smooth. But never use an electric sharpener for crayons—they are too soft and will break off in the sharpener. Invest in a good handheld sharpener instead. Just make sure that you get one with a hole big enough to fit a crayon. It also helps to peel the paper down before you begin sharpening.

- Crayons create a large amount of wax debris as you work. If you don't deal with them as they arise, these flecks of crayon can stick to the paper and make unwanted marks. However, if you try to wipe the flecks away with your hand, you might create smudges that cannot be erased. Use a drafting brush to sweep away the debris that will inevitability build up on the paper as you color with crayon.

- If you choose to make black a dominant color in your design, it is important that you lay your lighter colors down first. NEVER apply black crayon first—it will smear into the lighter colors and ruin them.

COLOR BASICS

Although there are no real rules to coloring groovy, having a basic understanding of color theory can give you an advantage when choosing which colors to use for your designs.

WARM AND COOL COLORS

If you want your design to convey a warm or firey mood, then you'll want to use warm colors such as red, orange and yellow. If, on the other hand, you want to establish a calm, cool or tranquil feeling, use cool colors like green, blue and purple.

MONOCHROMATIC COLORS

A monochromatic color scheme consists of only one color used throughout, in varying shades and levels of intensity. Using a monochromatic color scheme is a good way to practice shading without having to worry about other colors.

ANALOGOUS COLORS

An analogous color scheme uses colors that sit next to or very close to each other on the color wheel. Using an analogous color scheme will allow you to apply multiple colors to your design while keeping it looking cohesive.

COMPLEMENTARY COLORS

Complementary colors are colors that sit opposite each other on the color wheel (red and green, for example). Pairing complementary colors in a way that they will work well together can be challenging, but the key is to just keep them well balanced.

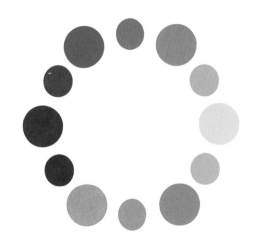

THE COLOR WHEEL

A simple color wheel can be a useful guideline when trying to decide what colors you should use. Reference it if you need some help or inspiration in choosing a color scheme. The color wheel consists of the following:

PRIMARY COLORS: the three main colors from which all other colors can be mixed (red, yellow and blue)

SECONDARY COLORS: colors created by mixing two primary colors together (purple, orange and green)

TERTIARY COLORS: colors created by mixing a primary color with a secondary color (red-orange, yellow-green, blue-violet, etc.)

COLOR THEORY IN PRACTICE

Here we can see all the basic principles of color theory put into practice in one composition. A monochromatic color scheme was used in the upper-right area with the red flowers. An analogous color scheme of blue and purple was used in the lower-right section. Complementary color contrasts abound with red/green, blue/orange and yellow/purple. And the equal use of both warm and cool colors balances out the piece as a whole.

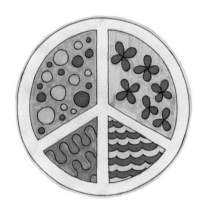

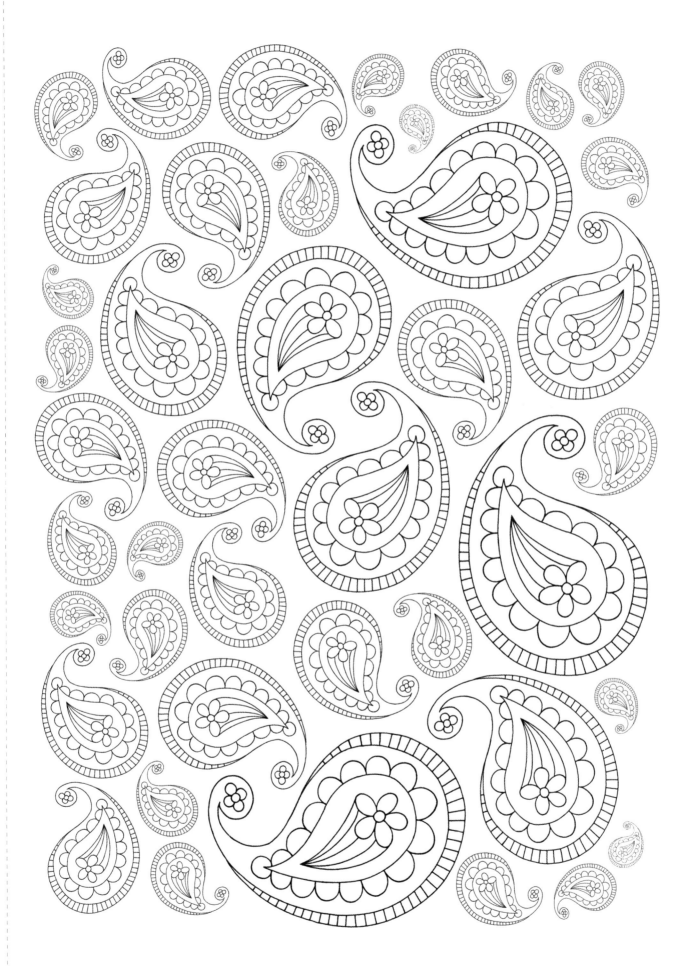

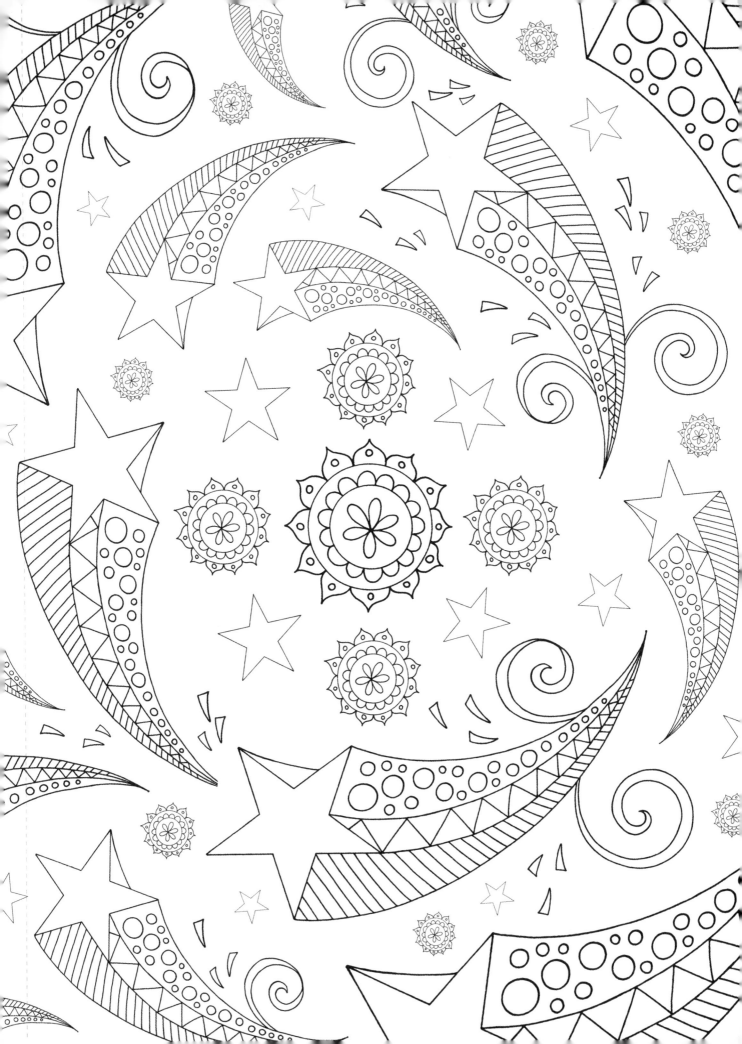

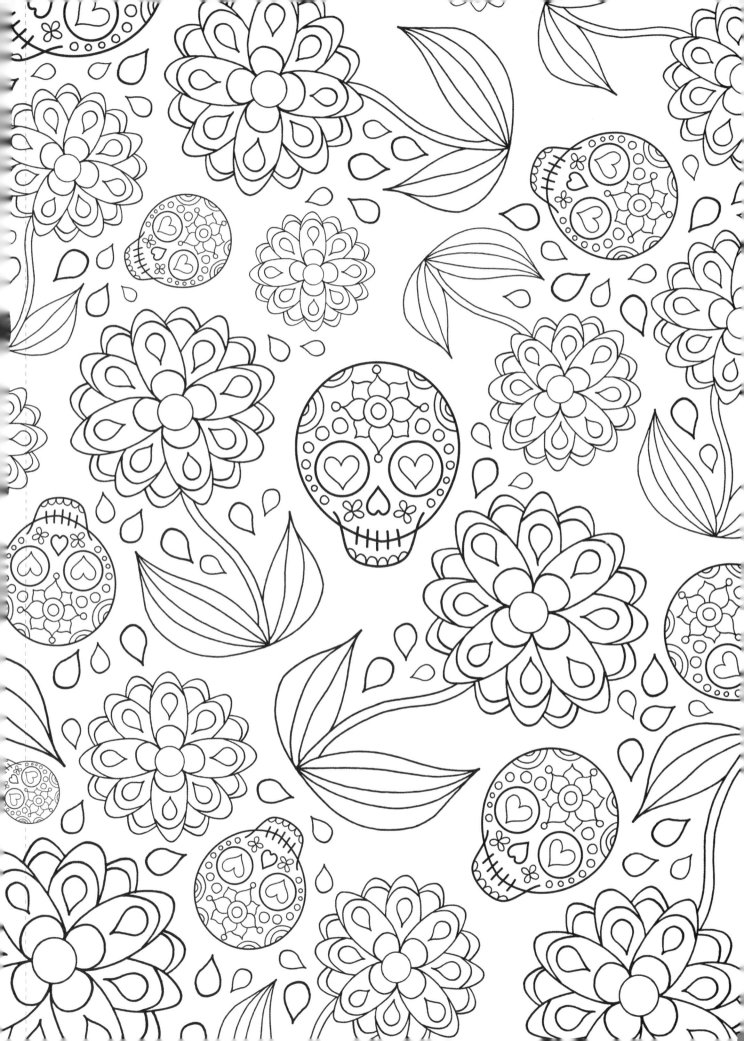

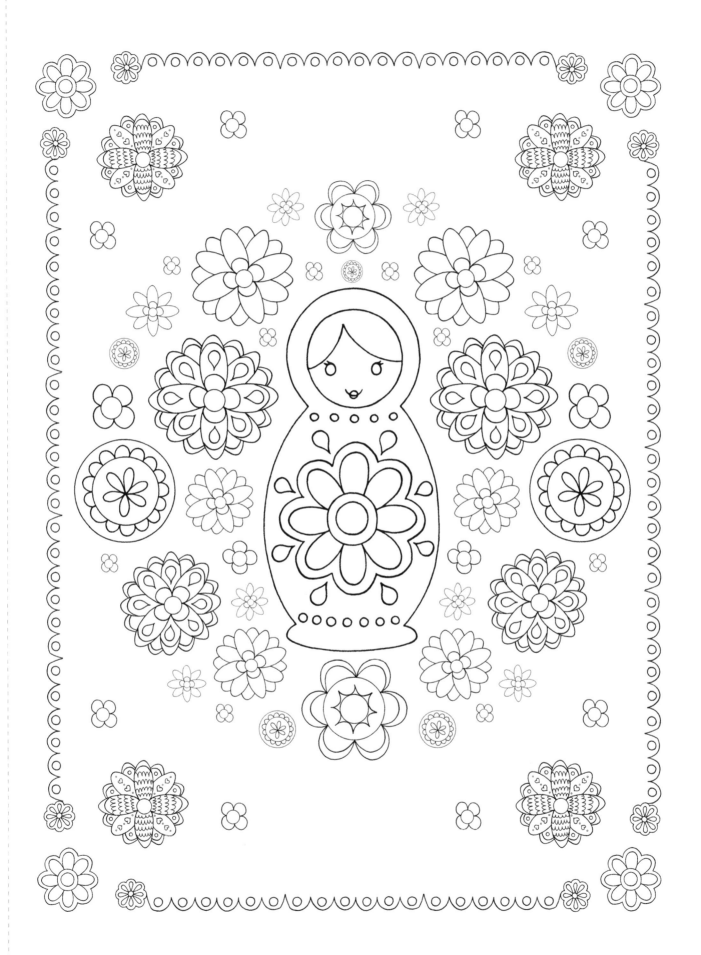

ABOUT THE AUTHOR

Thaneeya McArdle creates colorful art in a variety of styles, ranging from abstraction to photorealism. Her work hangs in private collections around the world, and it can also be purchased on t-shirts, stickers, coloring books and more. Thaneeya's first book, *Draw Groovy*, was published by IMPACT books in 2013. She also created the popular art instruction site, Art-is-Fun.com, where she shares her love of art with fun lessons and detailed information on drawing, painting and mixed media. Her site has received over 27 million page views and counting. Thaneeya is also the founder of The Art Colony, an online community for artists of all skill levels. In addition to art, Thaneeya loves to travel and learn new things. You can see more of Thaneeya's artwork at thaneeya.com.

a content + ecommerce company

Other fine North Light Books are available from your favorite bookstore, art supply store or online supplier. Visit our website at fwcommunity.com.

20 19 18 17 16 5 4 3 2 1

DISTRIBUTED IN CANADA BY FRASER DIRECT
100 Armstrong Avenue
Georgetown, ON, Canada L7G 5S4
Tel: (905) 877-4411

DISTRIBUTED IN THE U.K. AND EUROPE
BY F&W MEDIA INTERNATIONAL LTD
Brunel House, Forde Close, Newton Abbot, TQ12 4PU, UK
Tel: (+44) 1626 323200, Fax: (+44) 1626 323319
Email: enquiries@fwmedia.com

DISTRIBUTED IN AUSTRALIA BY CAPRICORN LINK
P.O. Box 704, S. Windsor NSW, 2756 Australia
Tel: (02) 4560-1600; Fax: (02) 4577 5288
Email: books@capricornlink.com.au

ISBN 13: 978-1-4403-4667-5

Edited by Christina Richards
Book design by Jamie Deanne
Coloring pages designed by Jamie Deanne with artwork by Thaneeyea McArdle
Production coordinated by Jen Bass

METRIC CONVERSION CHART

To convert	to	multiply by
Inches	Centimeters	2.54
Centimeters	Inches	0.4
Feet	Centimeters	30.5
Centimeters	Feet	0.03
Yards	Meters	0.9
Meters	Yards	1.1

Ideas. Instruction. Inspiration.

Receive FREE downloadable bonus materials when you sign up for our free newsletter at artistsnetwork.com/Newsletter_Thanks.

Find the latest issues of *The Artist's Magazine* on newsstands, or visit artistsnetwork.com.

 These and other fine North Light products are available at your favorite art & craft retailer, bookstore or online supplier. Visit our websites at artistsnetwork.com and artistsnetwork.tv.

Follow North Light Books for the latest news, free wallpapers, free demos and chances to win FREE BOOKS!

Visit artistsnetwork.com and get Jen's North Light Picks!

Get free step-by-step demonstrations along with reviews of the latest books, videos and downloads from Jennifer Lepore, Senior Editor and Online Education Manager at North Light Books.

Get involved
Learn from the experts. Join the conversation on